FACES & MAZES: *Lia Cook*

Wendy Weiss, Editor

Published by
Robert Hillestad Textiles Gallery
Textiles, Clothing and Design Department
College of Education and Human Sciences
University of Nebraska–Lincoln
Lincoln, Nebraska 68583-0802
textilegallery.unl.edu

ISBN 978 0-9748295-5-2

FACES & MAZES: *Lia Cook*

ROBERT HILLESTAD TEXTILES GALLERY
MAR 16 – APR 10, 2009
University of Nebraska–Lincoln
textilegallery.unl.edu

SCHOOL OF ART GALLERY
SEP 1 – 25, 2009
Kent State University
art.kent.edu

UNIVERSITY OF NORTH TEXAS ART GALLERY
NOV 10 – DEC 12, 2009
University of North Texas
gallery.unt.edu

GREGG MUSEUM OF ART & DESIGN
JAN 21 – MAY 15, 2009
North Carolina State University
www.ncsu.edu/gregg

SEPARATE EXHIBIT (WORKS ILLUSTRATED)
TEXTILE MUSEUM OF CANADA
APR 7 – SEP 6, 2010
Toronto, Ontario CA
www.textilemuseum.ca

DOWNLOAD AVAILABLE
PODCAST
Lia Cook at the University of Nebraskan–Lincoln
textilegallery.unl.edu/liacookpage

EXHIBITION *Calendar*

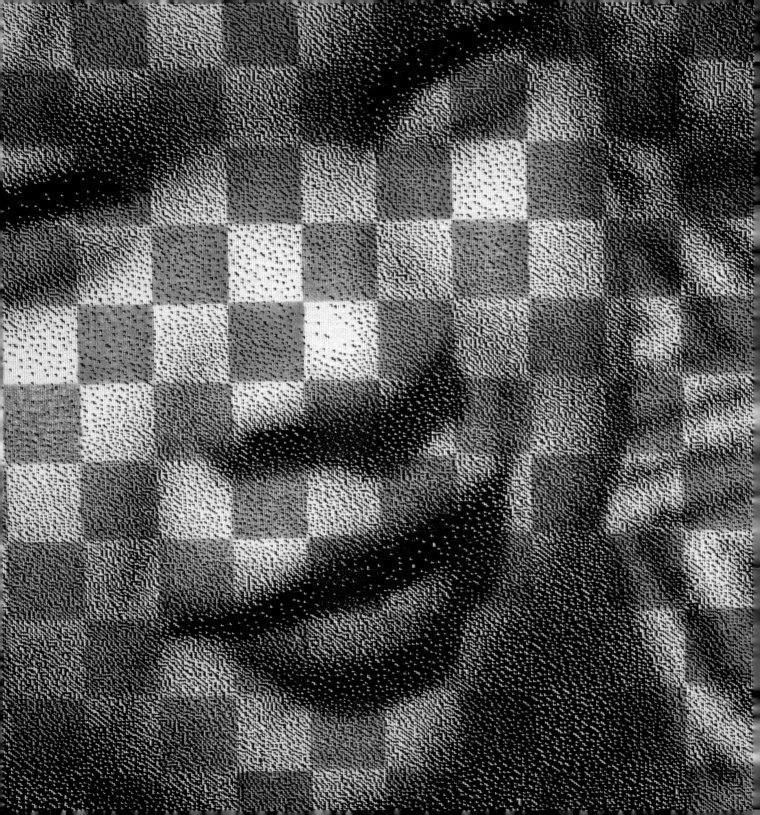

Acknowledgements

*T*his catalogue and exhibition tour, *Faces and Mazes: Lia Cook*, has been made possible with the support of the *Textiles, Clothing and Design Department*, which is housed in the College of Education and Human Sciences at the University of Nebraska–Lincoln. *Friends of Fiber Art International* have provided invaluable additional support, as have *all the host venues*. Without their enthusiasm and financial commitment, this catalogue could not have been produced. The *Friends of the Robert Hillestad Textiles Gallery* provide ongoing support to the gallery for programming.

Key individuals contributed to the success of the project, and I want to thank them. While I was absent working on an ikat documentation project through a Fulbright Nehru Research Award in India, *Michael James*, department chair, along with *Leah Sorenson-Hayes*, gallery staff assistant, and *Katie Taylor-Frisch*, graduate assistant, ensured that Cook's work was installed thoughtfully in the *Robert Hillestad Textiles Gallery* for the debut exhibition. *Rosanne Samuelson* maintains our gallery Web page and completes innumerable other tasks in support of the gallery's work. *Mike Kamm*, electronic media specialist for the university's Communications and Information Technology services expertly produced the podcast of Lia Cook discussing her work, viewable at: *http://textilegallery. unl.edu/liacookpage.* ●

Wendy Weiss, Curator & Director of the Robert Hillestad Textiles Gallery

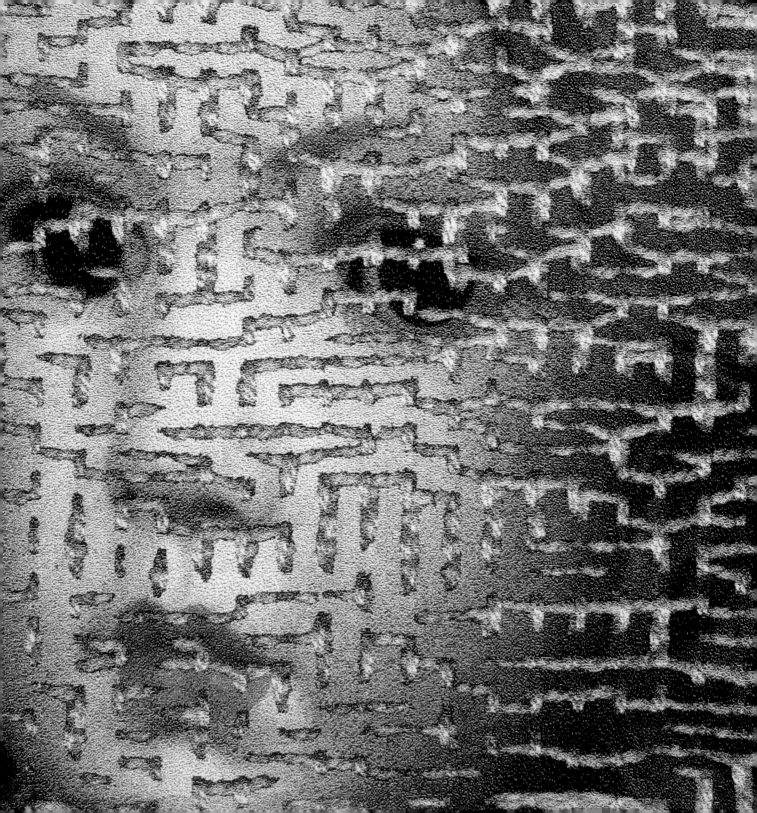

Weaving Life in Black and White

by Wendy Weiss
Curator & Director of the Robert Hillestad Textiles Gallery
Professor of Textiles, Clothing & Design
University of Nebraska–Lincoln

Faces and Mazes is an exhibition of unique electronic Jacquard loom hand weavings Lia Cook developed over the past six years in her studio in Oakland, California. In this current work, she examines both human and doll faces, embedded in a lattice-like weave structure. Cook is an artist whose depth and originality are explored in the two essays written by Christin Mamiya and Judith Leemann for this catalog. The work we are exhibiting flows from Cook's passion for extending our understanding of the interconnectedness of cloth as a medium of expression and a tactile experience. The essays that follow expand on these notions and provide multiple lenses for the viewer to consider this body of new work.

Cook has made a lifetime study of the potential of complex weave structure and material to express her ideas. This longstanding interest in the textile, as both subject of the work and the process through which it is made, continues to be evident in the imagery Cook is producing now. A prolific artist, she has completed several series of weavings that examine the interaction of structure and surface. The reference to fabric as subject is no longer the main idea; the shift is toward face or body as subject rather than identity as subject. The weavings continue to explore materiality. The body has become a stand-in for fabric; it is represented as pliable and evocative, as lived experience.

I have been following Lia Cook's art since 1980. I first met her in 1992 in Lodz, Poland, where we participated in a textile art symposium. She spoke powerfully about her work. I was especially impressed with Cook's notion of overlooked and disregarded textiles as subject, for example in her *New Masters* series in

which domestic textiles looted from old masters paintings become the center-piece of her woven canvas. She remains fascinated with the potential of using weave structure to create an expressive surface.

After studying photographs of Cook's maze weavings for nearly a year before I saw one, I was not prepared for the impression they make when I saw them directly. The scale itself is daunting and is of utmost importance in apprehending them. In the odd mixture of dolls and human subjects, the doll face becomes animated beneath the maze while the human face becomes statue still.

In *A-Maze Doll* (2008) an immense doll face stares out through a lattice of indeterminate form with a multiplicity of possible readings. The maze could be tear drops, drifting thoughts, window screen or hoarfrost, increasingly fragmented on the face to allow us to see the facial features. The grid of the maze layer separates visually from the image of the figure staring out. With eyes that gaze outward but stray from a full frontal view, the image is haunting, conveying longing and isolation.

Face Maps (2005) is a series of six small weavings. It fits in the hands like a book. Each of the six weavings is mounted on board, giving the individual weaving weight and substance, with the handwoven fabric pulled tightly around the 1/2-inch board, stretching the threads in the corners ever so slightly as they round the edge. The image extends to the borders of the top surface and turns solid white on all four sides. This presentation differs from the large work that forms the bulk of this exhibition.

The immediacy of these small pieces, which are fragments of faces enlarged in scale similar to that of the large weavings, but presented small, allows for a kind of contemplation that is akin to reading a book. One can pick them up, handle them, study the details of the threads interlacing in ever-shifting combinations of white and black. When first approaching these small images, one sees the marks as blurry abstractions. As one sets the work down and steps away, the image comes into focus and the mind works to establish the identity of the

PREVIOUS:
CINDY II
BABY BLUE
A-MAZE DOLL

RIGHT:
FACE MAPS (DETAIL)

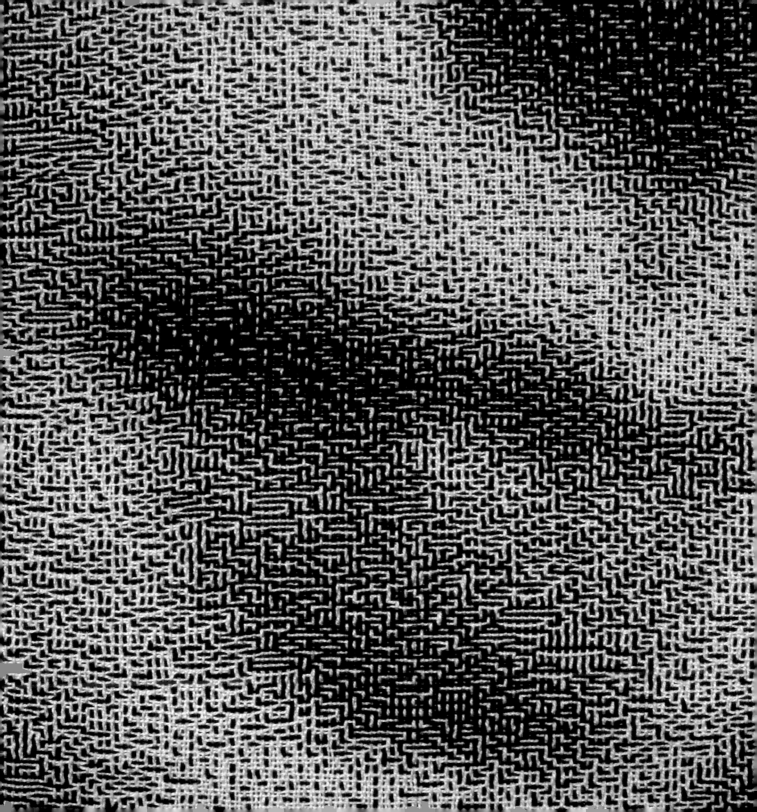

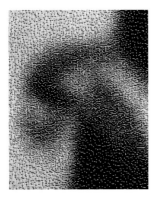 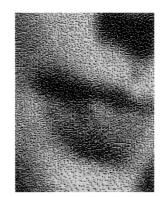

disembodied parts: a protruding tongue, an ear, a gaping mouth, a profile with lips and nostrils, a gazing eye, a set of lips and the shadow at the base of a nose.

These pieces are unlike the large faces, which confront the viewer in their entirety and demand an exchange. Rather, these fragments invite conjecture about the body and raw bodily functions. They imply the totality of a figure that inhabits a body, a body that reacts to sensations in a visceral way.

The weaver who looks at these pieces immediately recognizes the color and weave effect that form the foundation of Cook's maze group. In its simplest form, this technique is used to create a pattern called "log cabin" in which light and dark threads appear alternately in vertical and horizontal stripes. Cook has developed this idea to provide her with a full palette of lights and darks on a grey scale and has used extra weft threads in reds and blues to effect a tinting of the essentially black and white surface.

In conclusion, the work represented in this catalog and the guest essays detail how one artist has examined a multitude of relationships, combining a complex

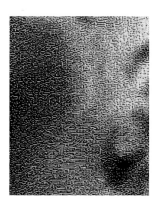 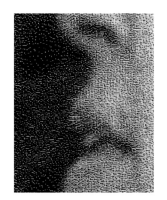 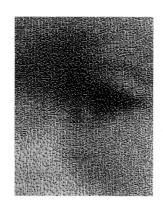

array of strategies to construct her work. Mamiya examines a set of significant binary relationships in Cook's work, including the dualities of hand and machine technology, abstraction and figuration among others, to establish the artist's historical place. Leemann explores the active state required of the viewer in looking at Cook's work. She, too, discusses layered differences — the interplay between digital and analog, real and imaginary — to understand how seeing and perception become intertwined as the viewer physically approaches to look at the weavings and discovers the recursive patterns structuring the work. The viewer completes the circle. ●

An unusual opportunity presented itself when developing the tour for this exhibition. The Textile Museum of Canada in Toronto requested the show at a time that overlapped with the commitment for exhibiting the work at the Gregg Museum in North Carolina. We decided to show a different selection of work from this same series in Toronto and include all the images for both groupings of work in the catalog. Consequently viewers must visit two venues to see the complete set of Faces and Mazes *presented here.*

Beyond Warp and Weft:
Dualities in the Work of Lia Cook

by Christin J. Mamiya
Hixson-Lied Professor of Art History
University of Nebraska–Lincoln

Response to the weavings of Lia Cook (b. 1942) is striking. One artist and writer described her experience: "The work I was looking at affected me so deeply I had to sit down. ... I sat there totally mesmerized by the image in front of me."[1] It is not hard to be enthralled by Cook's work. In contrast to much of contemporary art which seems to attempt to compete with the frenzy of everyday life by cranking up the volume, so to speak, Cook's work captivates through less aggressive means. Just what is it about these works that is so enticing? On an obvious level, her weavings are visually entrancing. But perhaps equally important is the conceptual investigation that is central to each work, and the way that Cook invites viewers to join her in this exploration. Cook's work, then, frames for and makes accessible to the viewer avenues of thought about art and life.

Woven cloth is produced from the intersection of warp and weft. Fundamental to the digital realm are the 0s and 1s that form the vocabulary of all digital code. Both of these are dualities — binaries.

> *What is perhaps the defining element of Cook's work is her deft ability to juggle recognized binaries and to create from the intersection or collision of these often-oppositional concepts a deeper resonance.*

In a world that seems riven by polarity (e.g., red states vs. blue states, pro-life vs. pro-choice, and Israeli vs. Palestinian), Lia Cook's work is notable because

[1] Carol Westfall, "Lia Cook," *Shuttle Spindle & Dyepot*, 36 (Winter 2004/2005), 32.

ESSAY BY *Christin J. Mamiya*

she juxtaposes concepts that are routinely seen as opposites. The results are intriguing; rather than present the viewer with simple contrasts, Cook produces impressively complex works that resonate with new meaning and get viewers to think about the relationship between concepts that are often defined by their opposition. Cook's interest in duality is suggested by her titles, for example, *Presence/Absence: Enfold* (1998), and *Binary Traces: Blur 2* (2004). Among the binaries that Cook incorporates into her work, all clearly evident in *Faces and Mazes*, are the handmade vs. the industrial; abstraction vs. figuration; two-dimensionality vs. three-dimensionality; and materiality vs. illusion. Less directly oppositional but still binary in character are part vs. whole and artificial vs. real. By diving "below" the woven surface of the textiles and exploring the conceptual depth of this work, it becomes evident that beyond providing captivating visual experiences, these weavings lure us, as viewers, into rethinking the fundamental nature of these concepts. In so doing, we arrive at a better understanding of the nature of the textile medium, we hone our ability to deal with visual material and, perhaps, we learn more about ourselves.

The most prominent feature of the works in *Faces and Mazes* is that they are woven. The loom on which these works were produced addresses the hand/machine divide. Cook's use of a digital Jacquard handloom and her incorporation of digital imagery alludes to the realm of technology, and more broadly, to industrialization. Ever since the rise of industrial practices over two centuries ago, artists have explored the relationship between the handmade and the industrial. With the diminishing prominence of artisanal culture over the past century or so as a result of industrial society's apparent preference for speed and multiplicity, the place of the handmade in modern society became increasingly precarious. Even in the art world, by the 1960s, artists such as Minimalist Donald Judd (1928–1994) were enhancing the cold, industrial quality of their sculptures by turning production of their works over to industrial foundries. Other artists have focused on art forms that are computer-generated or incorporate new technologies. Many of these artists have expressed skepticism about the ability of the handmade to adequately represent or even communicate with our overwhelmingly consumerist, technological society. Conversely, there have

PREVIOUS:
BINARY TRACES: BLUR 2

RIGHT:
MAZE GAZE

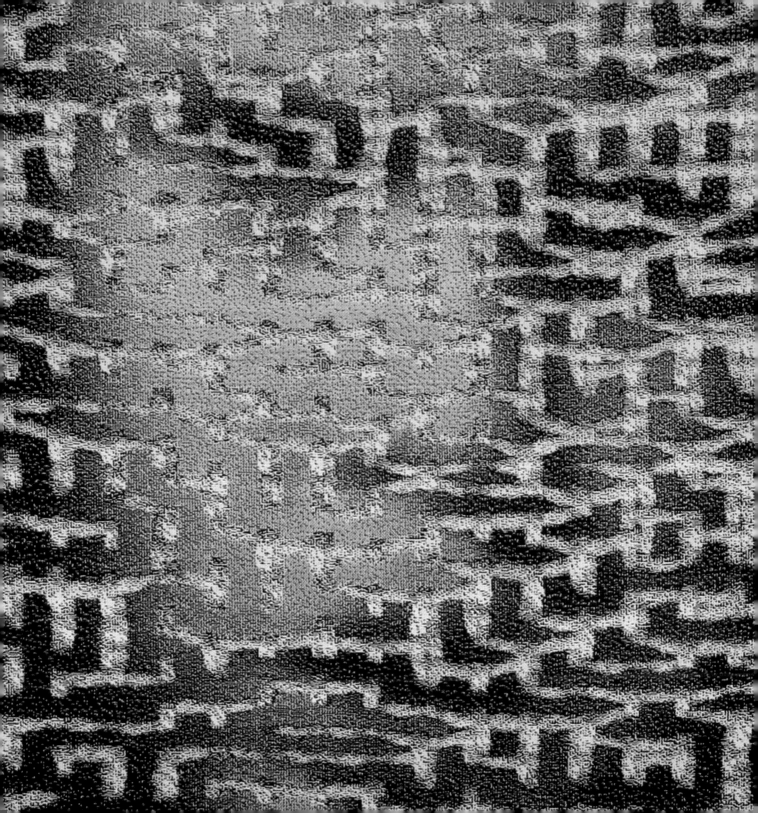

been artists who insist that the personal quality that emanates from the hand-made is a valuable and critical antidote to mass production. Liza Lou (b. 1969) is one such artist. The impact of her large-scale, environmental installations, such as a full-sized kitchen ("Kitchen", 1991–1994), for example, stems from the viewer's immediate recognition of the painstaking labor involved in the creation of these works entirely from miniscule glass beads, which Lou glues in place individually using tweezers. Although she does not make the beads herself, what is central to this work is hand labor — the fundamental value of the artisan or craftsperson.

Rather than planting her flag in one camp or another, Lia Cook straddles this divide, and in so doing, presents the viewer with fuel for further investigation and thought about the hand-machine relationship. Her approach is particularly intriguing because her works are handwoven, but on a digital Jacquard loom. Despite the outdated image of the weaving process on an individual loom as an intensive form of hand manufacture, the traditional Jacquard loom which emerged in the early 19th century has long been associated with industry and has been described by some as an early computer.[2] Curator and fiber artist Suzanne Baizerman describes the operation of the Jacquard loom: "The traditional Jacquard loom ... produces its images with a mechanism that operates a linked set of punched cards. For each row of weaving, the punched card determines whether an individual warp thread will be lifted up or down. As each card is engaged, another row is woven and the image emerges, row by row."[3]

The digital Jacquard loom that Cook currently employs allows her to use digital technology to manipulate the imagery and a computer-aided-design (CAD) program to translate that imagery into weaving instructions for a digital head on a hand loom. Cook's process thus invokes both the hand and the machine.

Still, her approach contrasts with those of artists like late-19th-century British architect and designer William Morris (1834–1896) who set as his goal the production of high quality, affordable pottery, furniture, textiles and wallpapers

[2] See, for example, Jenni Sorkin's discussion of the relationship between early loom technology and developing computer technology in "Weaving Possession" by Jenni Sorkin in *Portfolio Collection: Lia Cook* (Winchester England: Telos Art Publishing, 2002), 29–39.

[3] Suzanne Baizerman, "Image, Structure, and Emotion: Lia Cook's Recent Work," *Surface Design Journal*, 32 (Winter 2008), 16.

RIGHT:
FACE MAPS-3 GENERATIONS (DETAIL)

 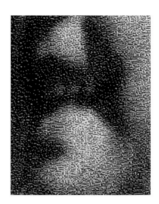

[4] From Target press
release at http://press-
room.target.com/pr/news/
target-home/graves/

[5] Artist interview in video
"The Art of Lia Cook:
Presence/Absence: the
Digital & the Hand,"
2002.

[6] Ibid.

ABOVE:
FACE MAPS-3 GENERA-
TIONS (SERIES)

available to the masses, and more recently, noted American architect Michael Graves (b. 1934), who has created a line of housewares for Target discount stores. According to the Target Corporation Web site, "the Michael Graves Design™ collection for Target represents the shared belief that people instinctively appreciate great design and that it should be affordable and accessible to all."[4] Although the Jacquard loom did contribute significantly to the industrialized production of more elaborate fabric, making such cloth available to more than the upper classes, Cook (unlike Morris and Graves) is not mass-producing her weavings, which retain the aura of one-of-a-kind artworks. The presentation of these works in art galleries frames or contextualizes them; despite the technological or industrial allusions, these are emphatically not Target commodities. Yet Cook's production of these works using a digital loom makes reference to the technological, if not industrial, realm. She acknowledges this dichotomy in her work. On the one hand, she describes her loom as "high-tech," noting that "this thing looks like airplane parts."[5] On the other hand, she asserts that this high-tech loom has allowed her to return to the emphasis on craft. "In a way, it started out as individual weavers weaving individual pieces of cloth," she explains. "It became mass-produced, and now with the coming of the computer,

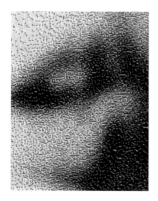 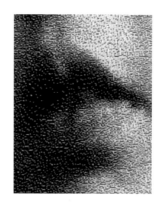 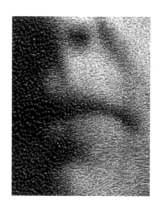

it actually goes back to being a more intimate and individualized process and I think that's what is very exciting about it."[6]

Perhaps more central to late-20th-century art than the hand/machine relationship was the antagonism between figuration and abstraction. For much of the 20th century, artists had liberally incorporated both abstract and representational elements, often within the same work; the German Expressionists are good examples of such artists. Largely due to the strident mid-century rhetoric of the influential critic Clement Greenberg (1909–1994), the relationship between abstraction and representation became much more polarized. In his 1979 publication *Clement Greenberg, Art Critic*, Donald Kuspit argued that for Greenberg, "the whole history of art [was] a matter of dialectical fluctuation between abstraction and representation."[7] As a result, during the latter part of the 20th century, abstraction and figuration became an either/or proposition for artists.

Although Greenberg's influence waned as Postmodernism was ushered onto the artistic stage in the 1970s, the perception that abstraction was the opposite of figuration has endured. Representation continues to be connected to visual illu-

[7] Donald B. Kuspit, *Clement Greenberg, Art Critic* (Madison: University of Wisconsin Press, 1979), 23.

[8] Clement Greenberg, "The Case for Abstract Art," in *Clement Greenberg: The Collected Essays and Criticism*, vol. 4, ed. John O'Brien (Chicago: University of Chicago Press, 1986), 78.

sion — representational artists produce work that is tied visually to the tangible world. As Greenberg put it, "Representational painting present[s] us with the images of things that are inconceivable outside time and place."[8] Abstraction, in contrast, stands on its own. Greenberg explained that abstraction is an "example of something that does not have to mean, or be useful for, anything other than itself."[9] Lia Cook's weavings address this binary in a compelling way; she presents images that appear as coherent representational images from afar but dissolve into abstract shapes up close.

> *Whether one sees Cook's weavings as either abstract or figurative therefore depends upon one's distance from the artworks. Like a Georges Seurat Pointillist painting or a Magic Eye® image, the pictures resolve differently at various distances and optical foci.*

This dialogue between figuration and abstraction is amplified by the fact that Cook often crops her imagery (e.g., *Face Maps*) or utilizes blurred and hazy imagery (e.g., *Maze Gaze*). Up close, these images seem defiantly abstract. This dynamic — the vacillation between abstraction and figuration — is important because it gives the viewer room to see (and see in different ways) and space to think. The experience of viewing the works thus becomes an integral part of the works.

In codifying the relationship between the abstract and the figurative, Clement Greenberg did not merely create oppositional camps; he actively and often stridently championed abstract art. Among the aspects of abstract art that most intrigued him was what he believed was its ability to convey purity or truth. "Purity in art," declared Greenberg, "consists in the acceptance, willing acceptance, of the limitations of the medium of the specific art."[10] In other words, artists should embrace and emphasize those qualities that defined the medium in which they worked — flatness, or two-dimensionality, for painters and three-dimensionality for sculptors. Greenberg praised the work of painters, such as Kenneth Noland (b. 1924) and Ellsworth Kelly (b. 1923), because their paintings — composed of areas of unmodulated color shapes — presented an obvious and

[9] *Ibid.,* 80.

[10] Clement Greenberg, "Towards a Newer Laocoön," in *Art in Theory, 1900–1990,* eds. Charles Harrison and Paul Wood (Oxford: Blackwell Publishers Ltd., 1992), 558.

RIGHT:
DOLL FACE II

emphatic flatness. In the realm of sculpture, the aggressively muscular objects produced by Minimal artists such as Richard Serra (b. 1939) were perceived by critics as exemplars of Greenbergian formalism because of their resolute three-dimensional objecthood.

The effect of Greenberg's artistic model was to polarize two-dimensionality and three-dimensionality. As with other established binaries, Cook incorporates both into her works. For example, she utilizes recognizable imagery, such as the human or doll faces, which we read as illusionistically three-dimensional (3-D), while the mazes, which extend like netting stretched across the surface of the weavings, reinforce the two-dimensional (2-D) nature of the weaving. Further, the evenness of the mazes and their vertical/horizontal orientation reiterate the warp/weft structure of the weaving itself, again speaking to the flatness of the woven textile.

But in a more complex fashion, Cook explores the implications of the two-dimension/three-dimension duality as well. Related concepts — illusion (3-D) vs. materiality (2-D), and the visual (the three-dimensionality of the images) vs. the tactile (the two-dimensionality of the fabric) — also emerge as notable aspects of Cook's work. On the one hand, the artist clearly intends for viewers to see images (faces, body parts) in her weavings. Yet it is also apparent that the materiality of the woven textile is equally significant. In discussing what happens when a viewer moves closer to her work, she explains,

> *"What was important was not just that the image dissolved into particles of color, but that in the act of fragmenting the image, the physical tactile presence of the threads became dominant, reminding the viewers of the sensual pleasure of touch."*[11]

To enhance the viewer's awareness of touch — tactility and materiality — Cook uses hefty threads of a wider diameter specifically because she wants "the viewer to be aware of the individual threads moving over and under one another."[12] Critics often refer to this dialogue between the visual and tactile, or 2-D and

[11] From Lia Cook, "Weaving, New Technology and Content," paper presented at the College Art Association Annual Meeting, 2007, cited in Suzanne Baizerman, "Image, Structure, and Emotion: Lia Cook's Recent Work," 19.

[12] From Lia Cook, "The Jacquard Loom in Contemporary Textile Art and Education," paper presented at the International Symposium of the Fondazione della Seta Lizio, 2007, cited in Suzanne Baizerman, "Image, Structure, and Emotion: Lia Cook's Recent Work," 19.

[13] Sigrid Wortmann Weltge, "Lia Cook: Nancy Margolis Gallery, New York, New York," *American Craft*, 62 (April/May 2002), 92.

RIGHT:
VOICES

3-D, when describing Cook's work. One reviewer of a Cook exhibition described how "texture and weave vie with the pictorial," alluding to the competition or polarity between the two-dimensionality of the woven textile and the three-dimensional illusion of the depicted imagery.[13]

Cook's work crosses other divides — ones that are perhaps less oppositional in nature. Among these dualities are part/whole, and real/artificial. The relationship between part and whole is particularly germane when dealing with the human body. Artists throughout history have explored the ability of body parts to serve as metaphors or substitutes for the human form. Sculptors such as Auguste Rodin (1840–1917) persistently explored the ability of a hand or leg to capture a meaningful gesture, a thought or a human condition. Cook's *Face Maps* and *Face Maps—3 Generations* function in the same way. Fragmentary though they may be, we scrutinize the body parts in these pieces and glean from them not just descriptive information, but emotional and psychological information as well.

The collision between the artificial and the real tends to surface most clearly in the imagery, e.g., frozen, haunting doll faces juxtaposed against weavings that hone in on blurry human faces (sometimes those of the artist herself). The relationship between the real and the artificial has become arguably more urgent in recent years, as we increasingly inhabit a world in which those distinctions become ever more difficult to make. A 1982 television commercial illustrates this point nicely. The now-iconic ad for a company that produced recording tape asked viewers/listeners to determine "Is it live, or is it Memorex?" Shortly thereafter, in 1985, French theorist Jean Baudrillard (1929–2007) decried the advance of ersatz culture in his sweepingly influential publication, *Simulacres et Simulation*. In this book, he posited the notion that we are moving toward a world that is entirely artificial (i.e., simulations of the real), to the point where we can no longer identify the real. From objects made out of simulated wood to fake fur, and from artificial sweetener to contrived "reality" shows, our connections to the real are under assault, and, at best, are seriously frayed. Indeed, the popular 1999 movie, "The Matrix," about people living in a world that they

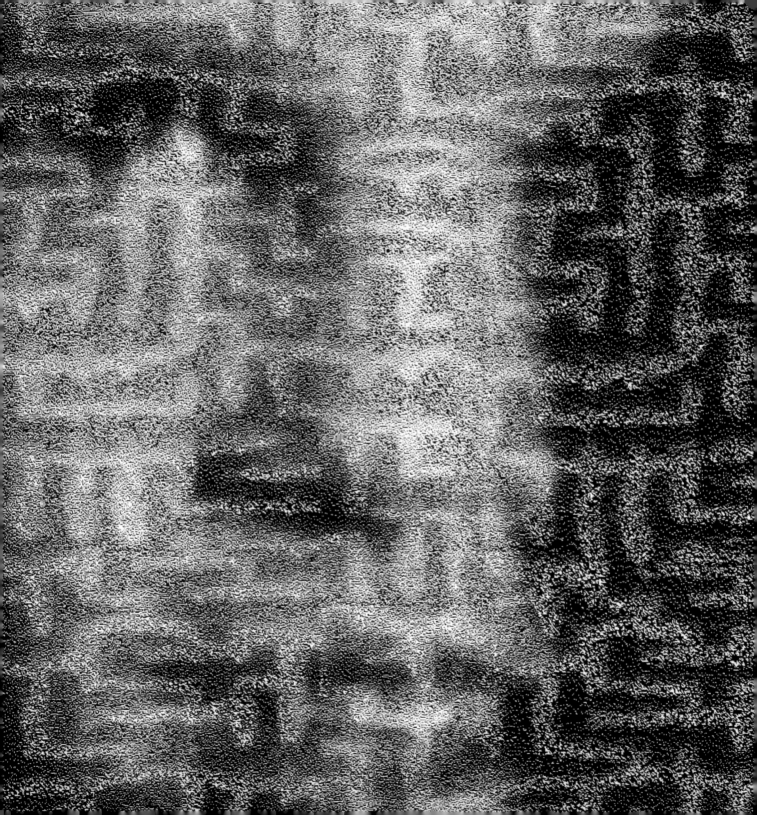

think is real but which is, in actuality, a massive simulation, was based on ideas in *Simulacres et Simulation*.

Looking at the juxtaposition of works like *Doll Face* II to *Voices*, or *A-Maze Doll* to *In the Maze*, there is an emotional richness and nuance — a reality — embedded in the human faces, in part because the expressions are enigmatically hazy and require the viewer's investigation. The doll faces, in contrast, evoke emotions as well, but in a different way, by dredging up memories and personal connections.

In the end, the impact of Lia Cook's work resides in its ability to make us see, think and feel. In dealing with so many binaries and concepts, the artist runs a significant risk of having the works devolve into a frustratingly cryptic hodge-podge. The fact that the works have such impact and coherence, both individually and as a group, attests to Cook's immense technical and artistic skills, and to her intellectual limberness. Even her approach reveals yet another binary — the problem-solving, technical, methodical interests of an engineer or scientist combined with the innovative, creative, intuitive responses of an artist. She once described her process as being "a strange conversation between me as the weaver and this image I'm building."[14] The result of that "strangeness" is unequivocal beauty, intensity and intimacy. ●

[14] Artist interview in video "The Art of Lia Cook: Presence/Absence: the Digital & the Hand," 2002.

RIGHT:
DOLL FACE III

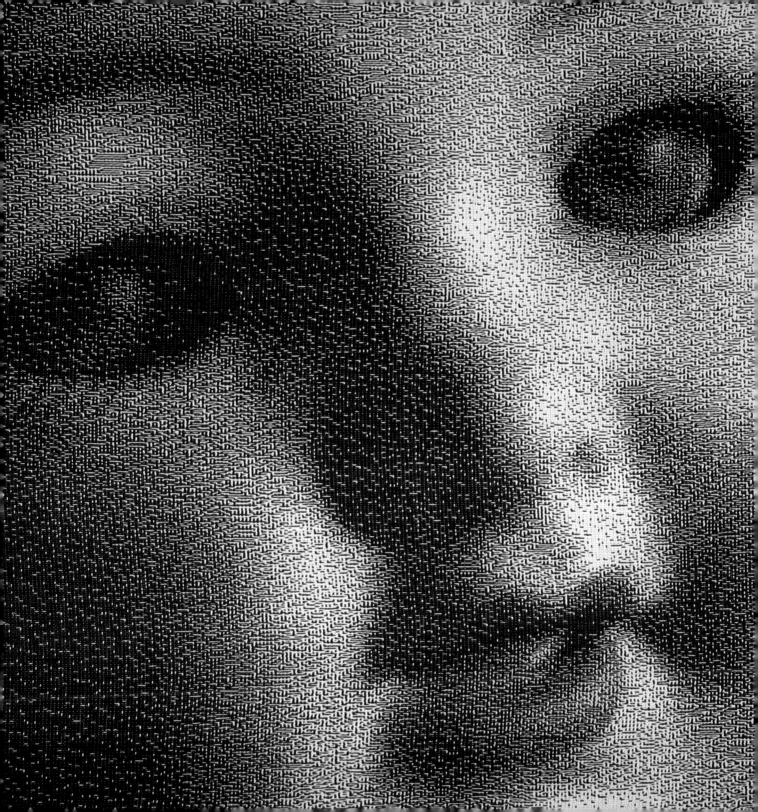

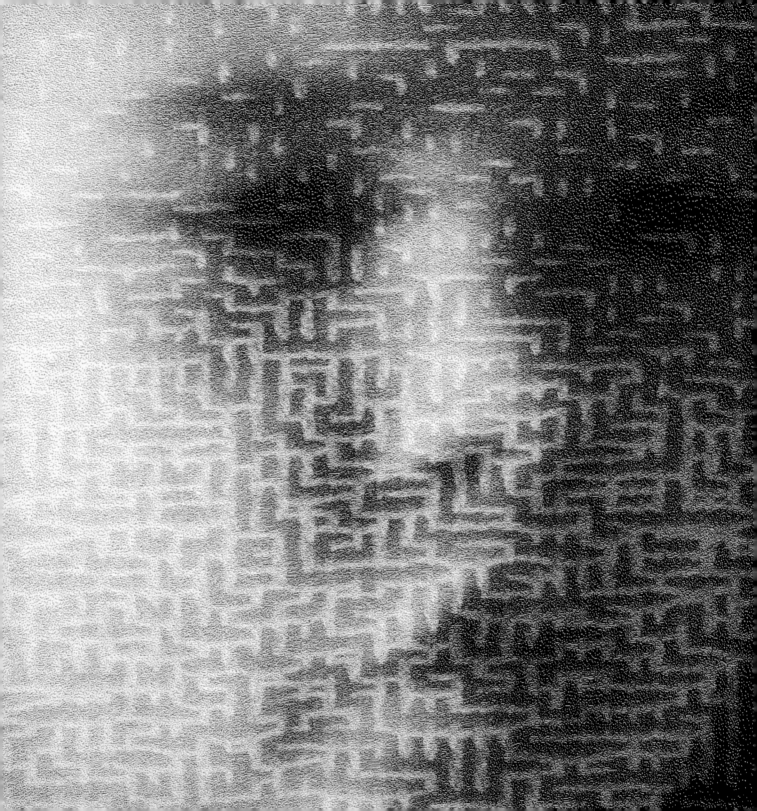

Don't Make That Face:
The Weavings of Lia Cook

by Judith Leemann
Boston-based artist, writer and educator

I recently encountered the term *affordance*, coined in 1977 by the psychologist James J. Gibson. Arguing against the perception of discrete qualities to which an observer then adds meaning, Gibson posits a more immediate recognition of what actions a thing (object, person, surface) affords. Affordance is located neither in the perceiver nor the perceived, but is rather a kind of second-order relation, pointing "two ways, to the environment and to the observer."[1]

> *Affordances are properties taken with reference to the observer. They are neither physical nor phenomenal.*[2]
>
> *An affordance is not bestowed upon an object by a need of an observer and his act of perceiving it. The object offers what it does because it is what it is.*[3]
>
> *The postbox "invites" the mailing of a letter, the handle "wants to be grasped," and things "tell us what to do with them."*[4]
>
> *The affordance of an object is what the infant begins by noticing. The meaning is observed before the substance and surface, the color and form, are seen as such.*[5]

One way to talk about an artist's work is to talk about what it *is*, to treat it as an endpoint. This is legitimate. But it's not the only way to punctuate the circuit that contains the making and viewing of art. I am curious what happens when

we take the work as the starting point, when we come to know the work by asking what the work produces, what it generates, or, to borrow Gibson's term, what the work *affords*.

> *When I first encountered Lia Cook's work, hanging in a Chicago gallery many years ago I was struck by its scale, its technical virtuosity, its sheer visual impact.*

I want to get this out of the way — to say "yes" to the high craft of the work; "yes" to its virtuosity; "yes" to the fascinating complexity that computer-assisted weaving makes possible; "yes" to scale that dwarfs us; "yes" to the irresistible *swimminess* of old family photos, and "no" to thinking that any of those things are the locus of the work's most insistent call.

In a review of a later show for the journal *Textile*, I described my first encounter with Cook's work:

> *Approaching one piece after the next, I became acutely aware of how the woven construction of the image frustrated my attempts to resolve that image. At a certain distance I could only see image, not thread. At another distance I could only see thread, not image. Standing at the precise threshold demarcating these two possible views of the work and rocking first forward then back, I found that the resulting perceptual confusion released a particular affective response — something in proximity of grief or longing though not exactly either of those. Something that in a story would be evoked by the word ago.*[6]

It is a common experience among viewers of Cook's work — this intense affective response — and it is one that will be entirely misattributed by anyone viewing documentation of her work on the page or screen. The still image deceives — it pretends the work is singular, it pretends the work is fixed, stays the same. With performance and other live art forms, we know that documentation is unreliable

[1] James J. Gibson, *The Ecological Approach to Visual Perception* (Boston: Houghton Mifflin Company, 1979), 141.

[2] *Ibid.*, 143.

[3] *Ibid.*, 139.

[4] *Ibid.*, 138.

[5] *Ibid.*, 134.

[6] Leemann, Judith, "Lia Cook: Re-Embodied." *Textile: The Journal of Cloth and Culture.* Vol. 5, No. 3 (December 2007), 333.

PREVIOUS:
MAZE GIRL

RIGHT:
WOVE GIRL

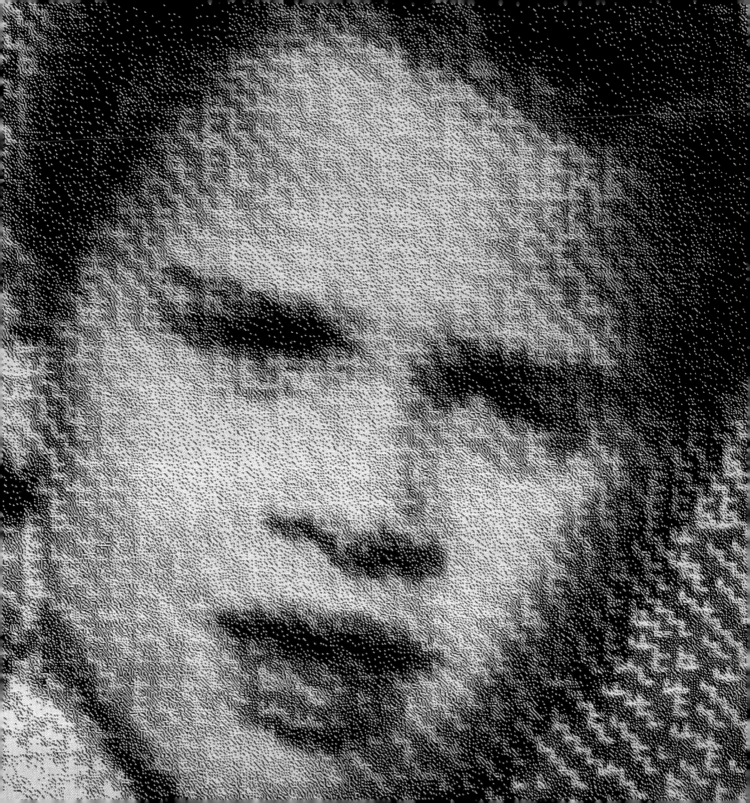

and cannot produce what the work itself produces. But with an essentially flat, frontally viewed image/object we think the photo of the work essentially does what the work itself does. But with Cook's work this isn't the case. And why it isn't the case is at the heart of what her work *does*, of how it *behaves*.

> *The experience of Cook's works on the page or from a fixed view-point will always have a false concreteness to it. The work is made to be encountered live and by a mobile viewer; it behaves live with a complexity that does not translate into documentation.*

On the page, or in stillness, the thresholds that are the distinguishing mark of the work just don't function. So you may press your face against the page, you may even smell fresh ink, but you will discover nothing of the perceptual bifurcation built into Cook's works by the relationship they take up with your eyes, your steps, your desire.

An encounter with Cook's work is an absolutely satisfying aesthetic experience, but her work affords something else that both exceeds the work's value as an art object and folds back into its value as such. What the work affords is a nuanced and rich experience of how things digital and things analog *behave*. Recall that in Gibson's theory, the affordance belongs neither to the object nor to the viewer. If it has a location, it is in the interaction. And so here, the embedded lesson on the nature of the digital and the analog belongs neither to the work nor to the viewer, but is located rather in the relationship between how Cook has constructed her work and how evolution has structured our perceptual systems.

The digital exists within the analog. The digital is a special and limited case of the analog. Discrete information does not exist outside of an analog matrix, outside of a continuum that includes the material, the affective, the live. Seeking language for my experience of Cook's work, I encounter the writing of Anthony Wilden, precise and often beautiful, moving fluidly between the terse language of mathematical logic and the poetics of the physical world. Sometimes the two modes collide in such singular phrases as "there simply aren't any gaps or holes in the natural world."[7]

[7] Anthony Wilden, *System and Structure: Essays in Communication and Exchange* (London: Tavistock Publications, 1980), 178.

RIGHT:
DOLL FACE

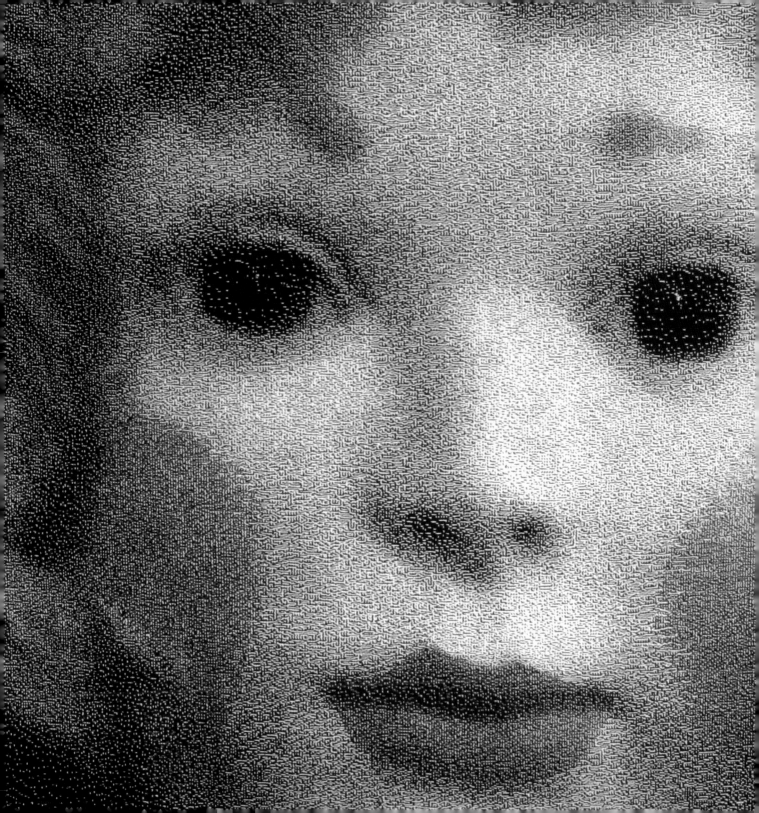

The analog (continuum) is a set which includes the digital (discontinuum) as a subset.[8]

The notion of the discrete being borne by the continuous is an interesting one, for it can be read as corresponding to the relationship between energy and information: continuous energy processes bear both (analog) differences and (digital) distinctions. Energy interferences in the channel contribute noise, and noise, as [Gregory] Bateson has pointed out, is the only possible source of new patterns. It is 'noise' in the genetic code which constitutes random variation in evolution. Information, by definition, is not random, and the 'noise' does not long remain as such, because of the adaptive characteristics of goalseeking open systems (language, minds, societies, organisms, ecosystems).[9]

There are thus two kinds of DIFFERENCE involved, and the distinction between them is essential. Analog differences are differences of magnitude, frequency, distribution, pattern, organization, and the like. Digital differences are those such as can be coded into DISTINCTIONS and OPPOSITIONS, and for this, there must be discrete elements with well-defined boundaries. In this sense, the sounds of speech are analog; phonology and the alphabet are digital. … Similarly, in order for the analog differences of presence and absence, raw and cooked, 'o' and 'a,' life and death, or the analog and the digital themselves, to be distinguished or to be opposed, they must first be digitalized either by the sender or the receiver or both in a language of discrete elements.[10]

We can say therefore that digital distinctions introduce GAPS into continuums (here the gap is filled by the empty set), whereas analog differences, such as presence and absence, FILL continuums. The line between presence and absence is not in fact a line at all.[11]

[8] *Ibid.,* 189.

[9] *Ibid.,* 169–170.

[10] *Ibid.,* 169.

[11] *Ibid.,* 186.

RIGHT:
BINARY TRACES:
SUSPECT

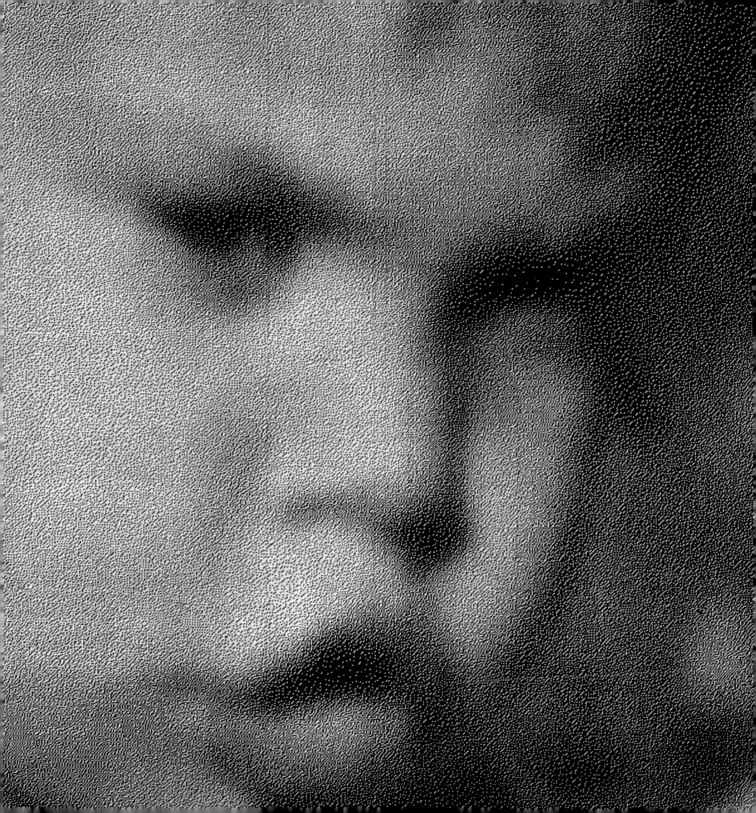

 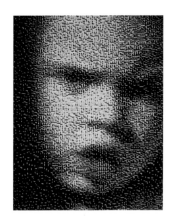 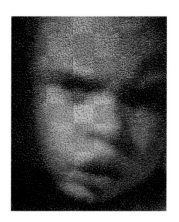

ABOVE:
TRIPTYCH
 SPOT FACE
 SU SERIES–LIPS
 SU SERIES–SQUARES

RIGHT:
SPOT FACE

You enter a room. Large works hang on walls or throughout the space itself. You and they exist in a physical continuum. Body touching air touching cloth. You see faces. Larger than you. Not clear, not resolved. You want to see a particular face more clearly. Your feet move you towards the face. You approach and some part of you registers that though you approach, the face doesn't in fact get any clearer. By force of habit you keep moving closer. Note the absence of gradient — the face never becomes clearer. At a precise moment though, something new does come into focus and that something new is thread. Black and white. Up and down. Showing or hidden. At the precise moment that it becomes possible to see the thread, it became impossible to see the face. If you want to see the face again you have to step back. You lose the thread and you gain again the face. So the work has precisely two states, with a threshold between those two states.

I suggest that perfectly reliable and automatic tests for reality are involved in the working of a perceptual system. They do not have to be intellectual. A surface is seen with more or less definition as the accommodation of the lens changes; an image is

not. A surface becomes clearer when fixated; an image does not. A surface can be scanned; an image cannot. ... No image can be scrutinized — not an afterimage, not a so-called eidetic image, not the image in a dream, and not even a hallucination. ... The most decisive test for reality is whether you can discover new features and details by the act of scrutiny. Can you obtain new stimulation and extract new information from it? Is the information inexhaustible? Is there more to be seen?[12]

Cook's works trouble the distinction between surface and image that Gibson so carefully articulates. The cloth is real. I can, by scrutiny, discover new features on its surface. But the face that it holds is not real. I can gain no new information on approach. It is image, imaginary, inscrutable, specular. In my still-unsatisfied desire to understand exactly what aspect of Cook's work consistently triggers such strong affective responses, I find one possible clue in this unsettled and unsettling oscillation between the real and the imagined.

If you could look at Cook's work as just a hanging blanket, there would be no threshold experience — the rectangular shape of the blanket would upon scrutiny reveal itself as textured, made of thread, thread in turn made of smaller fibers. But the rectangular surface and the patterning of those real threads give rise to something that is both compelling and simply not there, namely a face. A face you will never get closer to. A face with a fixed resolution. A face that will disappear at a limit set as much by your vision as by the scale of the threads Cook has selected.

In Cook's works, you are prevented from perceiving both image and surface at once. You either place yourself to see the face or you place yourself to see the threads. But memory leaves traces and so when you step back again having taken in how the work is constructed, you have a new experience which is (face/knowing it's really just threads). Stepping back in again you have the experience (black and white threads/knowing they make a face).

[12] Gibson, *The Ecological Approach to Visual Perception*, 256–257.

RIGHT:
SU SERIES–LIPS

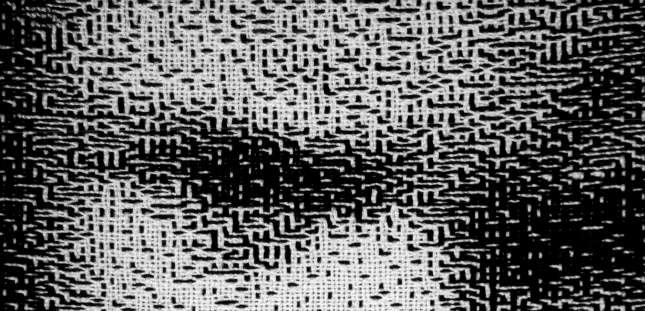

Typical of her insistence on folding patterns in on themselves, in recent works Cook takes this perceptual experience and materially inscribes it back onto the surface. What once existed within the mind of the viewer is now rendered physical. (Which doesn't mean it's not *still* happening in the mind of the viewer!) Now when I step back, that recalled sight of the threads making up the whole is there in front of me to be seen. Embedded. Afterimage becomes real. Large as it was in my field of view when I stepped in close to see the threads. And in rendering it as image, it takes on the face's inability to reward scrutiny with information.

Cook experiments with the rules by which the detail reinscribes itself. In *Maze Girl* (2006), *Wove Girl* (2006) and *In the Maze* (2005) the overlay behaves as the layering of two film negatives might, where anything white shows up and anything black simply lets the other layer through. So across the pale cheeks of the child we see very little of the overlayed detail but across her shadowed forehead we see an image of the patterning of threads, enlarged. In *A-Maze Doll* (2008) and in *Maze Gaze* (2007) the overlay is played so that the image of dimensional thread (the white only) sits atop the image of the doll's face as if embroidered on it in fat rope. It's worth trying to trace the imbricated patterning of image and material here as it teases the limits of how many levels of context a perceiving mind can hold at once. An image of fat white rope is made by weaving white and black threads to show the shading and highlights of that rope. The rope is only image, not real. The white and black threads were programmed to be in these exact locations, where they could produce the image of the fat white rope, by themselves being photographed and enlarged and translated via computer program from photograph into weaving draft. Trying to trace these relations produces in me much the same feeling as trying to track what happens when faced with "Disregard this sentence" or the famous "All Cretans are liars" spoken by the man from Crete.

The familiar catch of paradox has to do with its disregard of logical levels, its treatment of two things as parts of one whole, rather than as a part and a whole of which that part is a part. The anthropologist Gregory Bateson understood play in humans and animals as dealing in a similar confusion of logical levels.

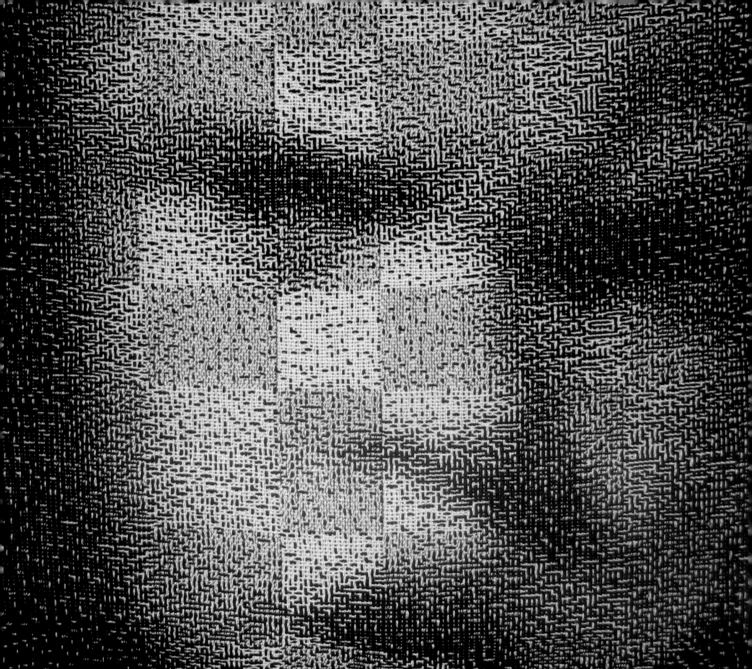

In observing the play of dogs, for example, he tried to understand how the animals communicated the difference between a nip that was play and a bite that was a bite. His characteristically precise gloss on what the nip communicates was this: "These actions in which we now engage do not denote what those actions *for which they stand* would denote."[13]

Which bears for me a striking resonance with Cook's reinscriptions of the part into the whole, moving that which was experienced in the analog (real) now into the realm of the digital (image) while leaving us still with the analog untouched and undiminished — those small threads are still there, are still real, even as they've been moved also into the realm of image.

Which brings me to one last thing. The faces do matter. To write simply about the structure of Cook's work is to ignore the way we respond to a face; is to ignore how much communication occurs in and across faces; is to ignore the revealing and hiding of faces and what they communicate.

Eve Sedgwick and Adam Frank, in the introduction to *Shame and Its Sisters: A Silvan Tomkins Reader*, articulate the central role played by the face in Tomkins' theory of affect. And within that theory of affect, the central role Tomkins understood shame to play.

> More than the place where affects are expressed, *Tomkins shows the face to be the main place in the body — though by no means the only one — where affect* happens.[14]

> *The centrality of the face in affective experience may also be seen in the relationship between the hand and the face. The hand acts as if the face is the site of feeling. Thus when one is tired or sleepy, the hand commonly either nurtures the face, in trying to hold it up, to remain awake, or attempts counteractive therapy by rubbing the forehead and eyes as if to wipe away the fatigue or sleepiness. ...* [15]

[13] Gregory Bateson, *Steps to an Ecology of Mind: Collected Essays in Anthropology, Psychiatry, Evolution, and Epistemology* (Chicago: University of Chicago Press, 1972), 180.

[14] Eve Kosofsky Sedgwick and Adam Frank, eds. *Shame and Its Sisters: A Silvan Tomkins Reader* (Durham: Duke University Press, 1995), 30.

[15] *Ibid.*, 30.

RIGHT:
FACE MAPS REVISIONED: RMH

We are inclined to favor the theory that shame is an innate auxiliary affect and a specific inhibitor of continuing interest and enjoyment. Like disgust, it operates ordinarily only after interest or enjoyment has been activated, and inhibits one or the other or both. The innate activator of shame is the incomplete reduction of interest or joy. Hence any barrier to further exploration which partially reduces interest or the smile of enjoyment will activate the lowering of the head and eyes in shame and reduce further exploration or self-exposure powered by excitement or joy. Such a barrier might be because one is suddenly looked at by one who is strange, or because one wishes to look at or commune with another person but suddenly cannot because he is strange, or one expected him to be familiar but he suddenly appears unfamiliar, or one started to smile but found one was smiling at a stranger.[16]

Shame is both an interruption and a further impediment to communication, which is itself communicated. When one hangs one's head or drops one's eyelids or averts one's gaze, one has communicated one's shame and both the face and the self unwittingly become more visible, to the self and others.

The very act whose aim is to reduce facial communication is in some measure self-defeating. Particularly when the face blushes, shame is compounded. And so it happens that one is as ashamed of being ashamed as of anything else. Thus occurs both the taboo on looking directly into the eyes of the other and the equal taboo on looking away too visibly. In short, self-consciousness and shame are tightly linked because the shame response itself so dramatically calls attention to the face.[17]

[16] *Ibid.,* 134–135.

[17] *Ibid.,* 137.

RIGHT:
CINDY LAY

A flow and an interruption in that flow. The interruption is both a break in the flow *and* a thing carried forward unbroken on that flow, communicated via that flow.

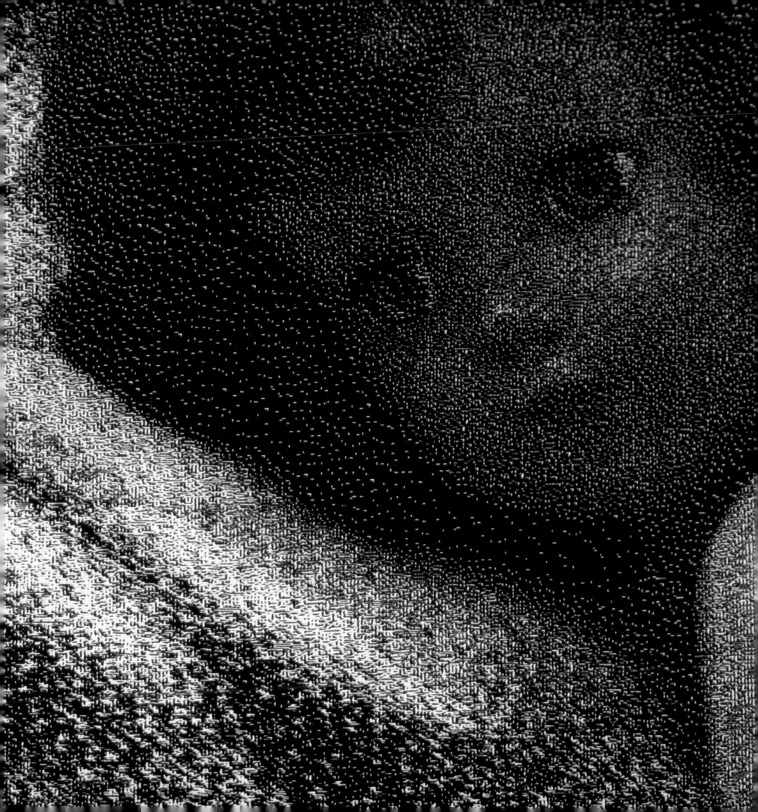

If Cook's work is *about* anything, it is *about* this. But it also *is* this.

And by *this* I mean shame and the way it is a reduction of communication, communicated. And by *this* I mean that to make a distinction between the digital and the analog is itself to impose a digital distinction on an irreducible analog whole. And by *this* I mean that the formal pattern we call paradox and that affords our minds a good riddle now and again also riddles the crossing of thresholds from child to adult with impossible choices. And by *this* I mean that I wouldn't be thinking such things were it not for time spent face to face with the imbricated material logics that emerge from Lia Cook's studio. And by *this* I mean to go back to the beginning and to say it as Gibson said it: *The object offers what it does because it is what it is.* And what the *it* of Cook's work *does* is circle, and circulate, and fold back on itself, and reinscribe the detail within the whole, and on the whole behave exactly like the rest of this world of which it is but one small, inanimate part. This, paradoxically, strikes me as remarkable. ●

Right:
Face Maze:
 Dolly Girl

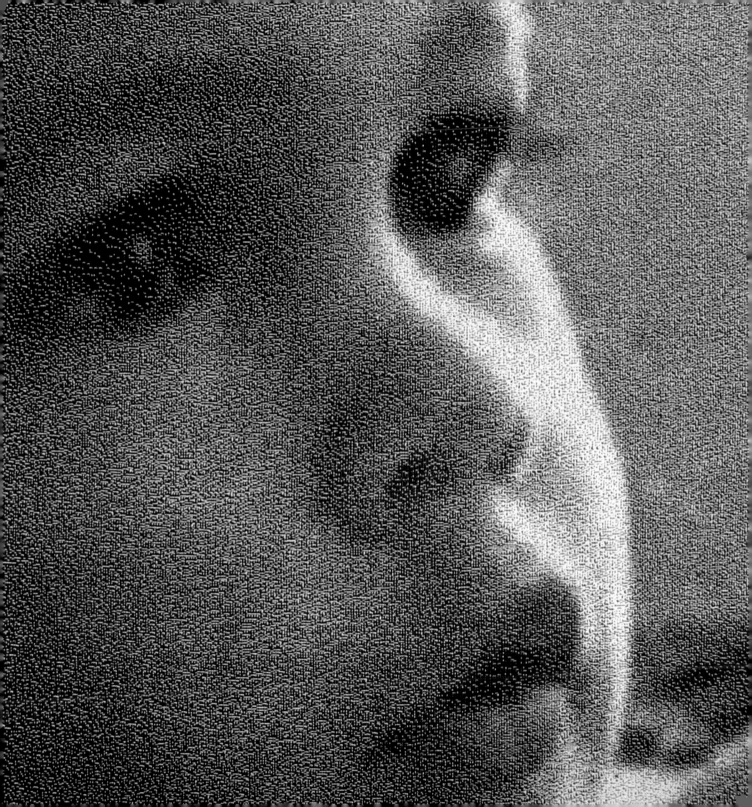

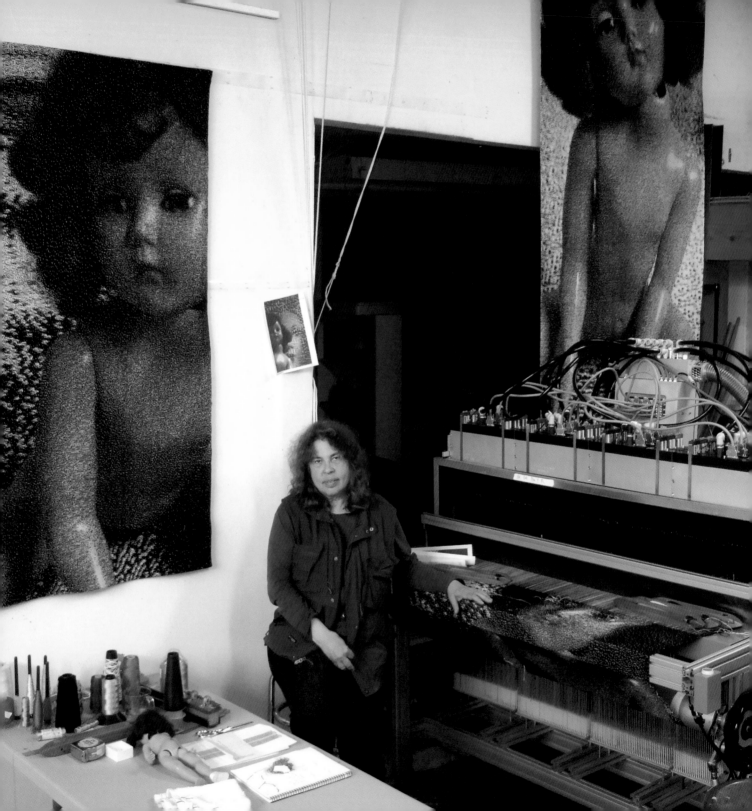

Biography

Lia Cook is a professor of art at the California College of Arts in Oakland, where she has dedicated herself as a teacher and colleague since 1976. She completed both her undergraduate and graduate work at the University of California, Berkeley where she studied political science and painting and worked closely with Ed Rossbach during her graduate program.

Fascinated with the potential of weave structure, Cook acquired an antique Jacquard loom head in Europe in the early 1980s and restored it to working condition in her studio. She researched the traditional Jacquard design process in which all work is done by hand and then pioneered the use of the electronic Jacquard handloom both in her studio work and in the classroom while teaching. Currently, she produces her weavings on a loom with 2,640 independently programmable warp threads. She uses photographic and weave software to design her work.

Cook has earned numerous awards, including the Excellence award from the Museum of Kyoto, Japan, at the *3rd International Textile Competition* '89 and a National Endowment for the Arts Fellowship in 1992. The American Craft Council named her a Fellow in 1997. She exhibits her work in solo and group exhibitions internationally, with over 90 shows since 2000. In 1992 she participated in the *15th International Biennial, Contemporary Textile Art* at the Musée cantonal des Beaux-Arts, Lausanne, Switzerland, and in 2006 her work was featured in *Design Life Now, National Design Triennial* at the Cooper-Hewitt National Design Museum, New York, NY.

Browngrotta Arts in Wilton, Connecticut; the Nancy Margolis Gallery in New York City and the Perimeter Gallery in Chicago represent Cook's work.

www.liacook.com
liacook.blogspot.com

BIOGRAPHY *Lia Cook*

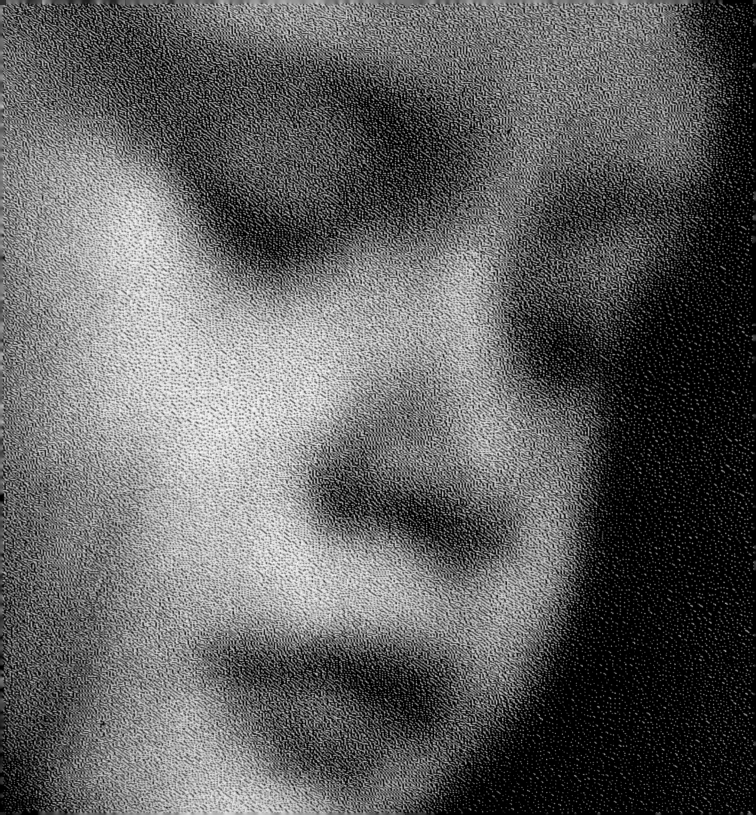

A-Maze Doll, 2008
WOVEN, COTTON & RAYON
80 X 53 INCHES

Binary Traces: Memory, 2004
WOVEN, COTTON
52 X 50 INCHES

Doll Face, 2007
WOVEN, COTTON & RAYON
92 X 52 INCHES

Doll Face II, 2008
WOVEN, COTTON & RAYON
71 X 50 INCHES

Doll Face III, 2008
WOVEN, COTTON & RAYON
35 X 52 INCHES

Face Maps, 2005
WOVEN, COTTON
10 X 8 INCHES EACH

In the Maze, 2005
WOVEN, COTTON
66 X 53 INCHES

Maze Gaze, 2007
WOVEN, COTTON & RAYON
72 X 52 INCHES

Maze Girl, 2006
WOVEN, COTTON
80 X 53 INCHES

Triptych, 2008
WOVEN, COTTON & RAYON

Spot Face
16 X 12 INCHES

Su Series—Lips
16 X 12 1/2 INCHES

Su Series—Squares
16 X 13 INCHES

Voices, 2003
WOVEN, COTTON
74 X 55 INCHES

Wove Girl, 2006
WOVEN, COTTON
57 X 51 INCHES

CHECKLIST *Exhibition Tour*

ARTWORK *Exhibition Tour*

A-Maze Doll
PAGE 6

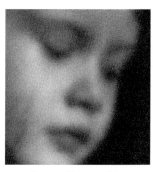

Binary Traces: Memory
PAGE 50

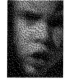 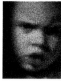 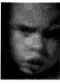

Spot Face PAGES 36 & 37
Su Series–Lips FT COVER, PAGES 36 & 39
Su Series–Squares PAGES 36 & 41

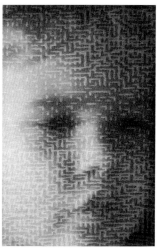

Maze Girl
PAGE 28

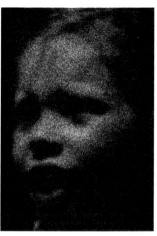

Voices
PAGE 23

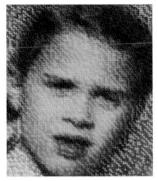

WOVE GIRL
PAGE 31

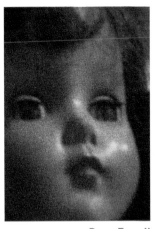

DOLL FACE II
PAGE 21

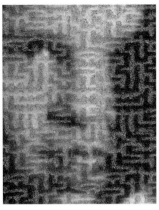

IN THE MAZE
PAGE 25

FACE MAPS
PAGES 9 (DETAIL), 10 & 11

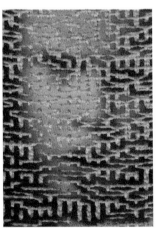

MAZE GAZE
PAGE 15

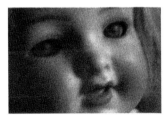

DOLL FACE III
PAGE 27

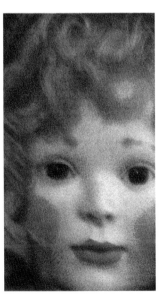

DOLL FACE
PAGE 33

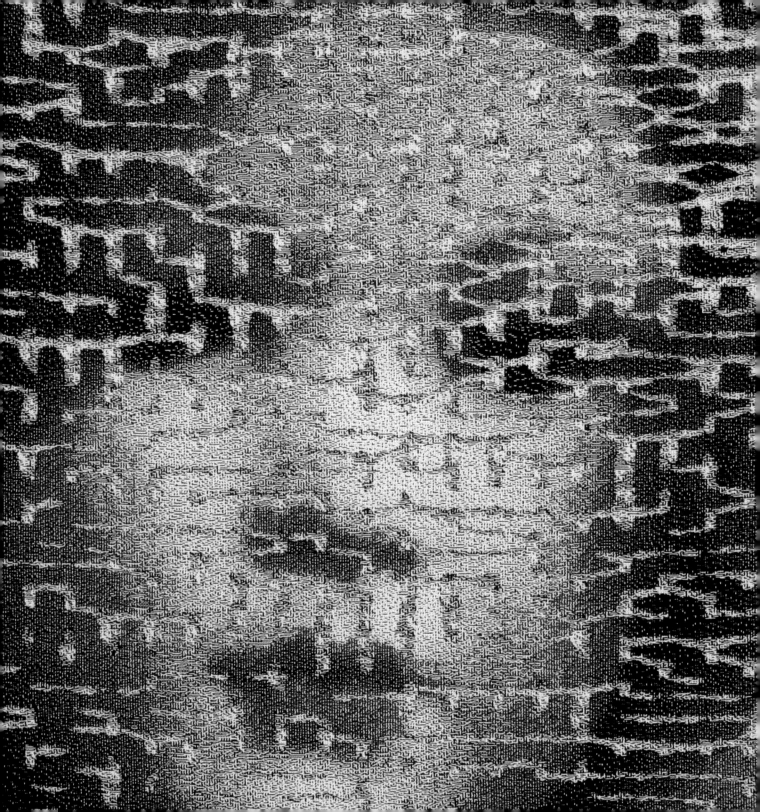

BABY BLUE, 2006
WOVEN, COTTON, OIL PAINT ON ACRYLIC
32 X 50 INCHES

BIG MAZE:
FOUR SQUARE CENTIMETERS, 2005
WOVEN, COTTON
51 X 52 INCHES

BINARY TRACES: BLUR 2, 2004
WOVEN, COTTON
58 X 50 INCHES

BINARY TRACES: IN YOUR FACE, 2004
WOVEN, COTTON
73 X 50 INCHES

BINARY TRACES: SUSPECT, 2004
WOVEN, COTTON
83 X 53 INCHES

CINDY II, 2009
WOVEN, COTTON & RAYON
68 X 51 INCHES

CINDY LAY, 2009
WOVEN, COTTON & RAYON
37 X 52 INCHES

CHINA MAZE DOLL, 2008
WOVEN, COTTON & RAYON
72 X 51 INCHES

FACE MAPS–3 GENERATIONS, 2006
WOVEN, COTTON
10 X 72 INCHES

FACE MAPS RE-VISIONED: RMH, 2006
WOVEN, COTTON
65 X 53 INCHES

FACE MAZE: DOLLY GIRL, 2009
WOVEN, COTTON & RAYON
65 X 52 INCHES

CHECKLIST *Toronto*

ARTWORK *Toronto*

CINDY LAY
PAGE 45

BIG MAZE: 4 SQUARE CENTIMENTERS
PAGE 58

FACE MAPS–3 GENERATIONS
PAGES 17 (DETAIL), 18 & 19

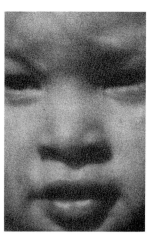

BINARY TRACES: IN YOUR FACE
PAGE 60

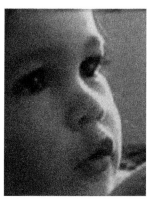

FACE MAZE: DOLLY GIRL
PAGE 47

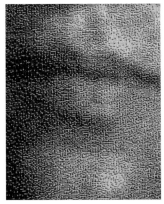

Face Maps Re-visioned: RMH
PAGE 43

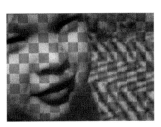

Baby Blue
PAGE 4

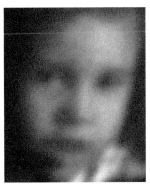

Binary Traces: Blur 2
PAGE 12

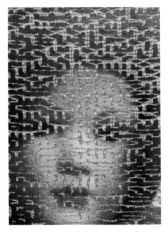

China Maze Doll
BK COVER (DETAIL) & PAGE 54

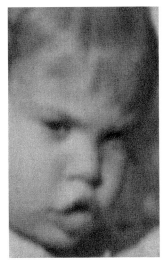

Binary Traces: Suspect
PAGE 35

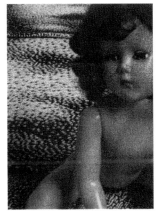

Cindy II
PAGE 2

FRIENDS OF
THE HILLESTAD
TEXTILES GALLERY

CELEBRATE CENTENNIAL
KENT STATE.
UNIVERSITY
1910·2010

 galleries

the GREGG MUSEUM
OF ART & DESIGN

Textile Museum
of Canada

SPONSORS

PHOTOGRAPHY
Courtesy of the artist

DESIGNER
Heather Morris

COPY EDITOR
Mel Wathen

PRINTER
Eagle Printing
Lincoln, Nebraska

TYPEFACES
Electra, Neutra, and
Kaufmann

FRONT COVER:
SU SERIES–LIPS

BACK COVER:
CHINA MAZE DOLL
(DETAIL)

PREVIOUS:
LIA COOK IN STUDIO
BINARY TRACES:
 MEMORY
CHINA MAZE DOLL
BIG MAZE: 4 SQUARE
 CENTIMETERS

RIGHT:
BINARY TRACES:
 IN YOUR FACE